It's a Still Life

Sculpture, paintings, drawings and photographs
from the Arts Council Collection

ARTS COUNCIL COLLECTION SOUTH BANK CENTRE 1989

Exhibition organised by Isobel Johnstone and Roger Malbert
assisted by Liz Allen, Lise Connellan and Jill Constantine

Catalogue designed by Arefin and Arefin
Printed by EGA Partnership, Brighton
Typesetting by Spencers, Clerkenwell, London

Photographs by Prudence Cuming Associates Ltd., Tim Head,
George Meyrick, Peter Neill, Ron O'Donnell, Eileen Tweedie,
Boyd Webb, John Webb

ISBN 1 85332 037 4

A full list of Arts Council and South Bank Centre
publications may be obtained from:
The Publications Office
South Bank Centre
Royal Festival Hall
Belvedere Road
London SE1 8XX

Cover: MICHAEL CRAIG-MARTIN *Painting and Picturing* 1978

Foreword

So well known and comforting is the idea of still-life that it is easy to miss the contradiction presented by the two words. There is more to this innocent-seeming genre than might be supposed, even in its most traditional forms. At the beginning of the modern period it was chosen as a vehicle for radical break-throughs. More recently, British artists have discovered a wealth of potential in the depiction and fabrication of objects in isolation and in interiors.

Most of the works on show were chosen from what already existed in the Collection and a very few were purchased more recently with this exhibition in mind. Inevitably there are omissions but there is variety and quality enough amply to support the case for the importance of still-life in contemporary British art.

The selection was made in collaboration with Roger Malbert, Regional Exhibition Organiser, whose introduction vividly establishes the depth and range of the subject. Deanna Petherbridge has been a constructive critic and has provided invaluable advice. Rather than present a single view the catalogue is an anthology with commentaries by the artists themselves and other writers.

The Arts Council Collection is the largest national loan collection of post-war British art. It has no permanent gallery. Instead, exhibitions are toured and many individual works are on view in galleries and other public places throughout the country. The Collection is now administered by the South Bank Centre on behalf of the Arts Council of Great Britain and based at the Hayward Gallery on the South Bank in London.

ISOBEL JOHNSTONE *Curator, Arts Council Collection*
JOANNA DREW *Director, Hayward & Regional Exhibitions*

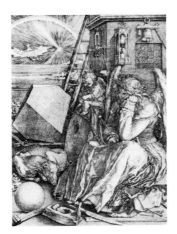

Albrecht Dürer, *Melencolia 1.* 1514,
Engraving

No Ideas But in Things[1]

The TV viewer's gaze drops from the dazzling screen. The inert, shadowy objects around it, tables, chairs, cups and magazines seem, after all that speed and emotion, an empty realm devoid of interest. Life is elsewhere when one looks at these things. As a subject for art, they must be low on the list. Perhaps, however, when an artist's imagination collapses and his attention wanders restlessly about the room, it might settle on such a silent assembly of indifferently arranged things, finding there an image of spectral significance, or a reflection of the mind's estrangement. And that image becomes, by a concentrated effort, the very subject of a picture, no longer an incidental accessory to a human drama but all the subject-matter that a picture needs.

Still-life was an ambiguous category in European art before the birth of the modern movement. Like landscape, its evolution can be traced through the Renaissance in religious and mythological paintings where it played a subordinate role, to gradual emergence as an autonomous subject.[2] Scenes conventionally set in a domestic interior, such as the Annunciation, the Last Supper and the saint in his study, were naturally hospitable to its cultivation. As a theme in its own right it is distinguished by what is missing — the human presence, the slightest intrusion of which would be sufficient to alter radically the emphasis and meaning of an image. With this exclusion, of course, much else is apparently lost which we expect to find in the greatest art: moral and psychological truth, passion, eroticism, pathos, action. In still-life, things speak, and their vocabulary is limited. The message, if there is one, is likely to be brief: an emblematic reminder of the transience of the material world, or a celebration of its beauty and variety, or a symbolic evocation of the transcendent. Or it may be nothing more meaningful than a hearty advertisement, in the bourgeois mode, for the good things in life, luxurious displays of acquisitions, food and merchandise; or conversely, a melancholy meditation on the few sparse belongings of the poor. The still-life also lends itself peculiarly well to exercises in verisimilitude, and attendant visual tricks and puzzles. The history of *trompe-l'oeil* painting is principally associated with still, small things easily simulated in two dimensions. The first popular anecdote of the still-life is Pliny's account, in the fourth century BC, of how Zeuxis painted grapes so realistically that birds were fooled into pecking at them.

1 William Carlos Williams;
'Paterson', Penguin Books 1983
'— Say it, no ideas but in things —
nothing but the blank faces of the houses
and cylindrical trees
bent, forked by preconception and accident —
split, furrowed, creased, mottled, stained —
secret — into the body of the light!'

2 Charles Sterling,
'Still Life Painting,
From Antiquity to the
Twentieth Century'
Harper and Row 1981

This form of art was held in low esteem by the Academies of England and France in the seventeenth and eighteenth centuries. Low genre scenes in the Dutch manner were afforded little respect by Sir Joshua Reynolds, generally a reliable exponent of officially-received opinion. In the Third Discourse, he rudely dismisses the artist who excels merely at rendering every detail of objects, plants or creatures, as on a level with the florist or collector of shells. "For the minute discriminations which distinguish one object of the same species from another" are of small account to the painter of genius; he, like the metaphysician, considers nature in the abstract, seeking to become possessed of "the great ideal perfection" which lies "above all singular forms, local customs, peculiarities and details of every kind". . . "It is not the eye, it is the mind, which the painter of genius desires to address; nor will he waste a moment upon those smaller objects, which only serve to catch the sense, to divide the attention, and to counteract the great design of speaking to the heart".[3]

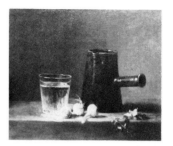

Chardin, *Glass of Water and Coffee Pot*, Pittsburgh Museum, Carnegie Institute

An effective answer to this is provided in an essay by Marcel Proust on Chardin, a near-contemporary of Reynolds, whose ambitions were more modest, but whose value to modern artists has been infinitely greater. "The artist is small-minded," Proust observes, "who seeks out in nature only those beings in whom he recognises the harmonious proportions of allegorical figures".[4] The true artist, he reminds us, is interested in people and phenomena of all sorts, regardless of whether they conform to classical canons of beauty or significance, just as the naturalist finds importance in every genus. People "whom age [has] turned red and eaten away, like rust", or mundane scenes in kitchens, such as those Chardin depicted, are worth as much to the true artist as visions of splendour and heroism. Proust reproves the snobbery of high-minded art-lovers who retreat to the museums to elevate their spirits while despising the common realities of daily life. "If when you look at a Chardin you can say to yourself, this is intimate, is comfortable, is alive like a kitchen, when you walk about a kitchen you will say to yourself, this is interesting, this is grand, this is beautiful like a Chardin . . . everyday life will delight you, if for a few days you have harkened to its depiction as to a lesson; and from having grasped that life in its depiction, you will have gained the beauty of life itself."

Since Impressionism, academic distinctions and hierarchies have become obsolete. The familiar world has on the whole provided artists with sufficient inspiration and no one would deny that a large proportion of the most profound and innovative painting of the past hundred years has had for its ostensible

3 Sir Joshua Reynolds, 'Discourses on Art', Yale University Press, 1981

4 Marcel Proust, 'Chardin and Rembrandt' in 'Against Saint Beuve and Other Essays', Penguin Books, 1988

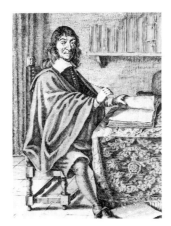

René Descartes, 1596-1650

subject things of very little consequence. The fact that still-life and domestic themes figure so prominently in the pioneering work of some of the greatest of the early modernists is evidence of their detachment from the values of public institutions and the marketplace. The still-life generally requires a disinterested, contemplative frame of mind; like the philosopher's study, the studio is a shelter for speculation, formal analysis, imaginative continuities and reverie.

Employing the metaphor of the house to illustrate the scope of his inquiry, Descartes outlines his plan for an investigation into the grounds of human knowledge. He does not wish, he assures us, to destroy every building in town in order to rebuild it according to sound principles; he intends nothing more radical than the reform of his own thoughts and "to build on a foundation which is wholly my own".[5] And since his house is to be demolished down to its foundations, every conventional belief questioned until a single incontrovertible truth is discovered, he moves into temporary lodgings, sheltering under a provisional moral code which permits him to live practically while his judgement is suspended. He resolves to obey the laws and customs of his country and in his behaviour to follow the example of the "most prudent" of his fellows.

Behind this guise of normality and good neighbourliness, Descartes pursues his sceptical method. He begins, conducting his thoughts "in an orderly way . . . with the simplest objects and the easiest to know, in order to climb gradually, as by degrees, as far as the knowledge of the most complex".

A close attention to the immediate objects of perception is a useful philosophical strategy for deflating the grand schemes of idealism. Empiricists, who seek to be rid of the obfuscations of metaphysics and religion, prefer to return directly to the data of the senses, the first source of knowledge. For we learn to interpret the world in our infancy through a gradual acquaintance with things seen, touched and named. Philosophy gives back to the mind the freedom to observe phenomena without prejudice: the effect of a stick which we know to be straight, bending under water, for example, or the variations in colour depending on the light. And these simple observations provide a basis for approaching such difficult, complex questions as the relation of knowledge to perception, and 'reality' to appearance.

Art too revolves around these questions, though not with the same regard for empirical certainty. In art Cézanne stands in an equivalent position to Descartes; he is the most philosophical of painters, methodical and infinitely patient in his attention to a very few motifs, and he is the overwhelming

5 René Descartes, 'Discourse on Method', Penguin Books, 1970

influence on subsequent generations. His famous precepts are echoed even today in every classroom where bottles and fruit are set up for study, to aid an understanding of form and the principles of composition. He defines the limits of his art in terms of the intrinsic properties of the medium: "Literature expresses itself by abstractions, whereas painting by means of drawing and colour gives concrete shape to sensations and perceptions" ... "To achieve progress nature alone counts, and the eye is trained through contact with her."[6]

For the sceptical thinker, as Descartes shows, the study of nature also entails reflection upon perception and the nature of the perceiving self. The objective world dissolves under analysis into a myriad of impressions. Cubist variations on the still-life beautifully illustrate this instability, and show the diversity of pictorial codes available to the modern artist once the Renaissance tradition of fixed-perspectival space is abandoned. With Cubism, a shift of emphasis occurs: the importance of the picture is no longer necessarily in the objects depicted, but the manner of their representation.

Philosophers in the twentieth century have attended closely to language, as the medium of thought, examining the ways in which its structures influence and shape our experience. So too have artists turned to reflect upon the formal and procedural conventions governing their activity. The relationships between language and the visual image have been a persistent theme of modern art, and one of the earliest manifestations of this concern was Cubism's introduction of fragments of text into the picture. These words are signs for things and surfaces, an element in the visual field (newspapers, café signs and labels) along with wallpaper patterns and playing cards. They evoke flatness but are also filled with the meanings — literal, punning, metaphorical — which overflow from the graphic notation. Words animate the picture, and remind us of the intellectual, poetic traditions of the emblematic still-life, to which the ironies of Cubism belong.

While language has continued to preoccupy artists, an equally important obsession has been the converse, but related, question: the status of the work of art as a material object, a made thing, co-existing in the world with other things. "The picture hangs on the wall like a rifle or a hat", wrote the philosopher Martin Heidegger.[7] "A painting, for example the one by Van Gogh that represents a pair of peasant shoes, travels from one exhibition to another ... Even the much vaunted aesthetic experience cannot get around the thingly aspect of the art work". Heidegger addresses this "thingly" element (what the

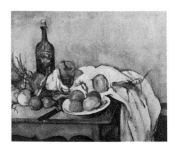

Paul Cezanne,
Still-Life with Onions,
c. 1896-8,
Musée du Louvre

6 Paul Cézanne, letters to Emile Bernard, from Herschel B. Chipp, 'Theories of Modern Art', University of California Press, Berkeley, 1968

7 Martin Heidegger, 'The Origin of the Work of Art', in 'Poetry, Language, Thought', Harper and Row, 1971
see also Jacques Derrida, 'Restitutions' in 'The Truth in Painting', University of Chicago Press 1987

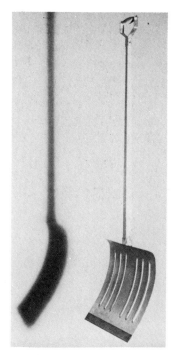

Marcel Duchamp, *In Advance of the Broken Arm*, Readymade, 1915

artist makes "by his handicraft") in order to "arrive at the immediate and full reality of the work of art", because he believes that language obstructs our perception of the world; grammatical structures impose a misleading duality on experience, falsely dividing matter from form. They prevent us from yielding to the "undisguised presence" of things, which art, through pictorial representation, discloses.

It is in sculpture, whose sphere the still-life really entered only in the twentieth century, where the subtle implications of this dialectic are most clearly revealed. The sculptural representation of an object belongs to the same realm as the object itself; in certain cases it may be indiscernible from, or even identical with, the original. Marcel Duchamp's Readymades are an instance of modernist irony and self-effacement taken to an extreme. The work of art depends for its preservation and appreciation on a precarious economy of signs and inherited values. As conventional ideas of craftsmanship, beauty and meaningfulness have broken down, the interplay between art and everyday objects and images has increased.

Today the imagery of advertising and the mass media overwhelms domestic life as never before. Emblazoned packages and mass-produced goods provide the basis for a universal culture. They are not simply objects and artefacts for use, but signs for a community of values. Artists have responded to this proliferation of imagery with varying degrees of enthusiasm, irony, cynicism or despair. Some have found in its banality a democratising influence. Pop art decisively opened up the field of consumer culture as worthwhile material for recycling. Recent work in photography and video has engaged more critically with the manipulative features of the home-entertainment industry. And feminists have cast an implacably unsentimental eye over the mythology of domestic life. Meanwhile, some social critics declare apocalyptically the end of authentic personal experience, as if the world might be reduced to nothing but signs — things-in-themselves having sunk beyond reach into the murky waters of ideology, to remain there only dimly discernible as fetishised commodities. The deadpan attribution of artistic status to brand-new consumer items by contemporary American sculptors, simultaneously denies and affirms the validity of art as a transcendent category exactly as Duchamp's Readymades did, with the additional irony of instant commercial success.

The quietistic ideal of the home as a sanctuary for innocence and private emotion has been eroded from all sides. In this context, the humble still-life

painter must seem an anachronism; Heidegger's faith in the power of art to disclose the reality of things "in truth" seems similarly outmoded. Yet there remains a notion of truth, inevitably associated with solitude and self-recognition, epitomised by a painter like Morandi. His position in the twentieth century would hardly be considered feasible, if it had not in fact been achieved. It represents the furthest pole from technology's Live-Action-Replays: the silent meditation in a slow medium on still things.

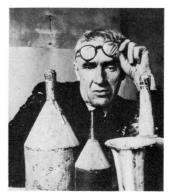

Giorgio Morandi.
Photo Herbert List

I have been fortunate enough to lead an uneventful life . . . I am essentially a painter of the kind of still-life composition that communicates a sense of tranquility and privacy . . . I have always avoided suggesting any metaphysical implications.

I suppose I remain . . . a believer in Art for Art's Sake rather than in Art for the sake of religion, of social justice or of national glory. Nothing is more alien to me than the art which sets out to serve other purposes than those implied in the work of art itself.

I believe that nothing can be more abstract than what we actually see. We know that all that we can see of the objective world as human beings, never really exists as we see and understand it. Matter exists, of course, but has no intrinsic meaning of its own, such as the meanings we attach to it. All we can know is that a cup is a cup, that a tree is a tree."

Morandi [8]

ROGER MALBERT

8 Quoted in Edouard Roditi, 'Dialogues on Art', Ross-Erikson, Santa Barbara, 1980

Illustrated page 40

Craigie Aitchison

Hilary Lane 'Room for Thought',
Arts Council Collection touring
exhibition, 1982

§ Craigie Aitchison's painting is made of simple elements, a triangle, a cylinder, curves, lines and rectangles. It seems poised on the edge of existence, as if it might disappear if any tiny part were taken away or overbalance if anything were added. It seems poised in time too, as if the stillness it expresses is momentary.

Illustrated page 39

Patrick Caulfield

§ The domestic interiors which Caulfield depicts are not those in which he would choose to live, but even at their most vulgar he does not look upon them patronisingly or with disdain.

Caulfield had hinted at the theme of the interior as early as *Corner of the Studio*, 1964, but he was afraid at that time that if he dealt with the theme in an explicit manner the result would be too illusionistic, too literal. In the first fully-realised interiors of 1969 he took account of this danger by describing all forms simply with black line against an expanse of a single flat colour. He thought of the picture as a large drawing superimposed on to a colour field, using the subject as 'an excuse to introduce all sorts of structures and things and give the painting a complicated linear pattern'.

Major changes took place in the form of Caulfield's work at this time. The paintings are larger than before, the format is usually vertical rather than horizontal or square, they are painted on canvas, and they are done in acrylic or in a combination of acrylic and oil rather than just in oil paint. All these changes can be accounted for by the subject matter with which he was now dealing. The logic of the one-to-one scale which Caulfield had been using in his still lifes was retained, so that the objects in the foreground of the interiors are life-size and the image as a whole corresponds to the size of a wall in a domestic room. The paintings are meant to hang low, and the viewer is encouraged to sense the possibility of walking into them, an effect maximised by the focusing of the perspective at one's eye-level.

The subtleties of different types of light are a constant concern in Caulfield's interiors. Often the source of light is depicted within the image itself

in such a way that light is actually reflected off that colour rather than merely represented. This is the case, with *Dining Recess*, which is dominated by an electric light suspended in a familiar paper lantern, contrasted with the diffused natural light which appears to flow in from above . . . However dramatic the effects of light, the social connotations of the imagery remain very strong . . . the ubiquitous Scandinavian design of the furniture in *Dining Recess*, suggest[s] slightly outdated suburban *nouveau riche* interiors. It was the very familiarity of these objects which attracted Caulfield, the fact that they were aimed at common consumption. Even the kind of room portrayed has a particular resonance; the 'dining recess', for instance is a feature illustrated often in books and magazines on interior design. 'It's an environment made by somebody for somebody else, not a personal environment', a fact that creates a marked feeling of unease in many of the interiors depicted by Caulfield.

Marco Livingstone 'Patrick Caulfield, Paintings 1963-81', Tate Gallery, London, and Walker Art Gallery, Liverpool 1981

Michael Craig-Martin

Illustrated page 19

Painting and Picturing is one of a series of works in which Michael Craig-Martin incorporated, in various ways, a small painting by an anonymous amateur artist into a larger canvas. As an act of appropriation of one artist's work by another, it may be compared with Duchamp's "Rectified Readymades", such as *LHOOQ* (the *Mona Lisa* with moustache and goatee) and *Apolinère Enameled*, and with the activity of recent 'appropriation artists' such as Sherrie Levine, who exactly replicates famous twentieth century photographs, drawings and paintings and exhibits them as her own work. The difference here is that absolutely nothing is done to alter or obscure the original. It is presented in its entirety, with only its context changed. The aim was "to maintain the full integrity of the little picture and at the same time radically unhinge it".

The outline drawing in tape on the empty canvas prefigures Craig-Martin's wall-drawings of the following ten years (this is the first completed work in which the tape appears). Like the wall works, it is concerned with codes of depiction. In this case the image, the line drawing, is derived from a painting, whose enlargement and transfiguration in this emphatic, formal way is ironical, implying an authority in the original which it cannot claim to possess. Normally, one copies or reproduces only a very good picture, whereas this one is like an

oddity from a junk shop. It has been chosen by Craig-Martin with Duchampian indifference. *RM*

Illustrated page 20

Cathy de Monchaux

Although highly suggestive, *Ferment* resists easy classification. The piece is carefully and systematically crafted to give the impression of belonging to the real, working world, of having a rational purpose. This is a kind of subterfuge. The hardware suggests functional equipment and the velvet a protective container or carrying-case for something valuable. It might be taken for a weapon or a musical instrument. The contrast of materials signifies perhaps an opposition of elements: it is a bisexual object, container and contained in one. All its elements are familiar, yet it has a language of its own, ambiguous and ingeniously playful. In order to make the work, de Monchaux says, it is necessary to keep oneself entertained by it, and a note of laughter may be detected behind the impossible hinges and handles, and the flagrant sexual metaphor. *Ferment* is entertaining and it is also beautifully poised, between sensuousness and mechanical precision. *RM*

Illustrated page 17

Stephen Farthing

§ From Easter to September 1982, Farthing rented a spacious studio on the seafront at Whitstable and there began painting large-scale domestic interiors from drawings that he had begun the previous Christmas. The horizontal format of these canvases, which had their source in the novels of Balzac, suggested that they were like mirror images of actual rooms. They were much more than illustrations to literary texts, for his interpretations were fleshed out by his own experiences, memories and imagination.

One passage from Balzac's novel *Eugénie Grandet*, describing the main room of that 'grey, cold, silent house' in which the old miser lived, is particularly pertinent . . . Balzac, like other French naturalist writers of the 19th century, lent an air of objective reporting to his tales of human interaction by supplying

(Continued page 22)

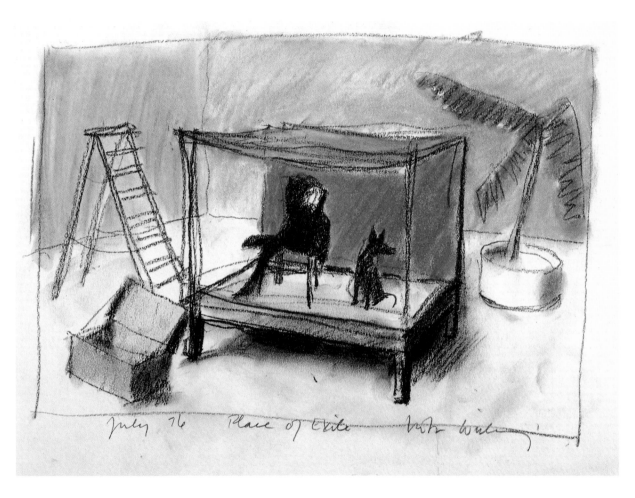

VICTOR WILLING
Place of Exile 1976

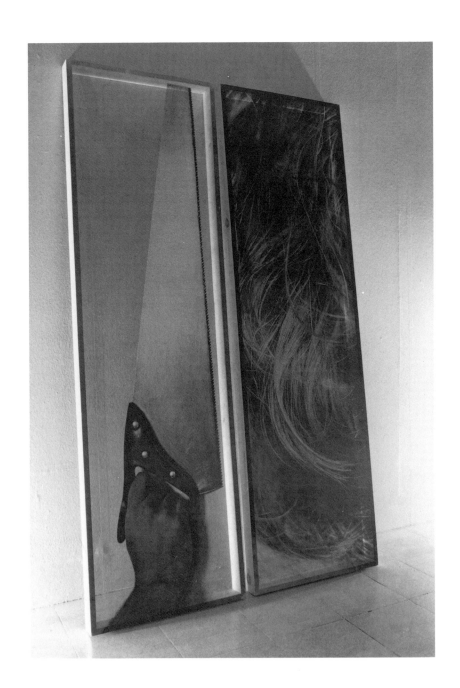

MARYSIA LEWANDOWSKA
The Missing Text:
Saw and Hair 1988

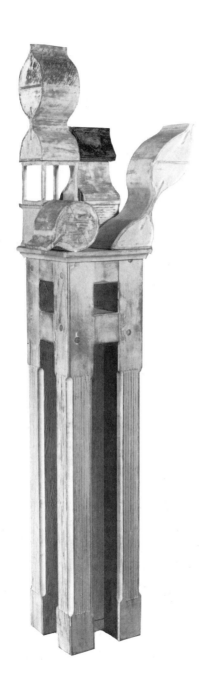

GEOFFREY SMEDLEY
Bicameral Solids 1979-80

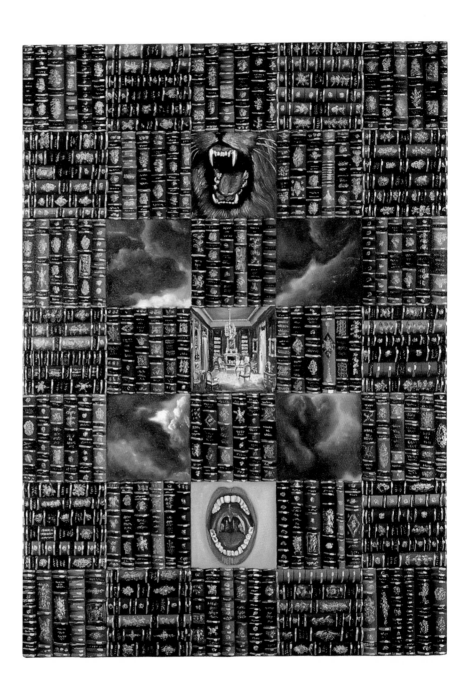

SUZANNE TREISTER
The Black Hole 1987

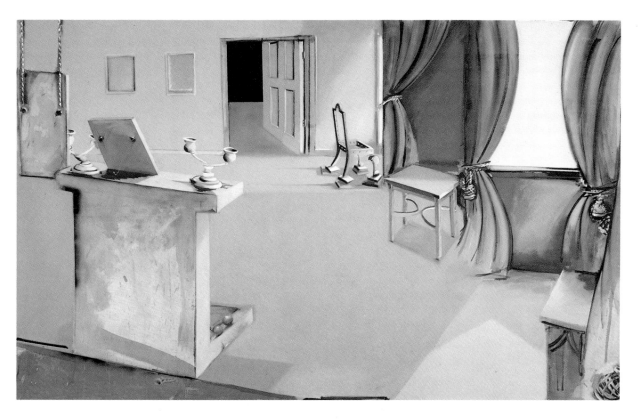

STEPHEN FARTHING
Mrs G's Chair 1982

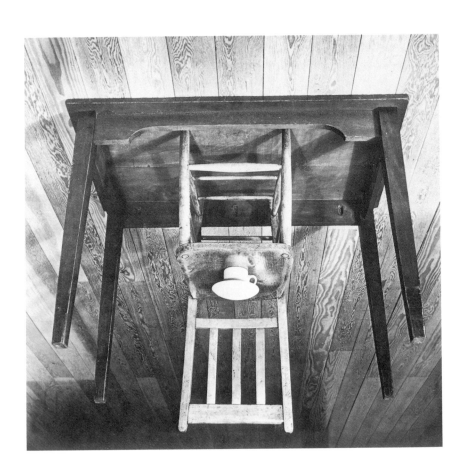

TIM HEAD
Levity I 1978

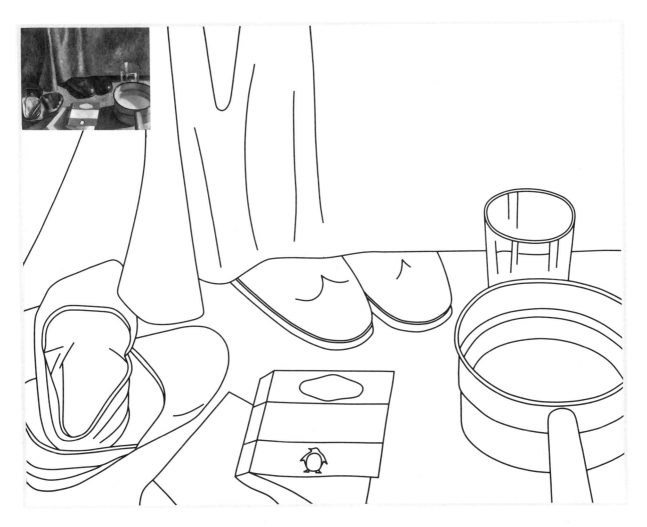

MICHAEL CRAIG-MARTIN
Painting and Picturing 1978

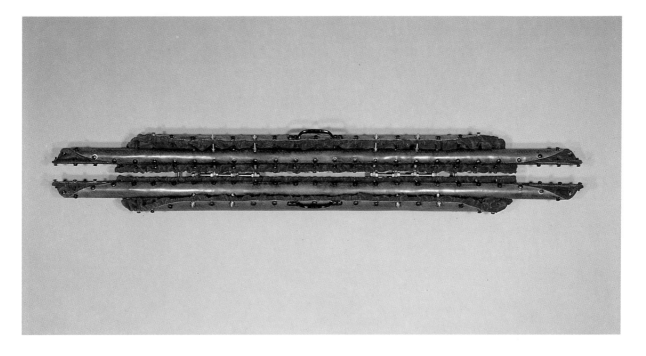

CATHY DE MONCHAUX
Ferment 1988

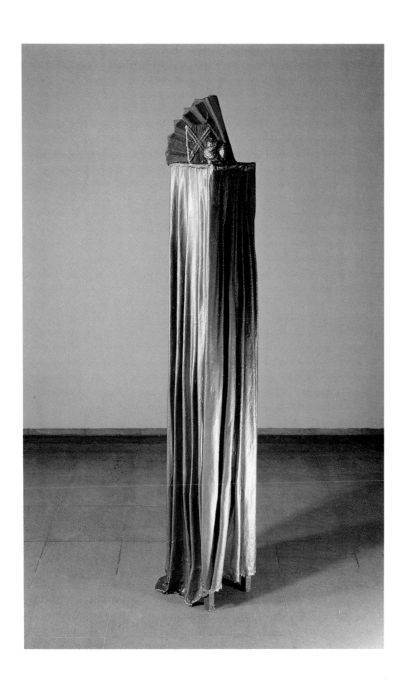

DI LIVEY
Domestic Piece One 1980

lengthy catalogues of the attributes and possessions of his protagonists. The similarity of such descriptions to stage directions helped to induce the distinctly theatrical air of these paintings. The room is treated as a world in itself; nothing can be seen through the window for the simple reason that, like the room as a whole, it is an abstraction, a figment of our collective imagination. Farthing was particularly intrigued by the way in which Balzac's comments took no note of the fourth, unseen, wall, as if accepting that the room he was describing was no more than a stage for the human drama being enacted. This sense of the wall as a transparent surface opened up immense pictorial possibilities in dealing with an architectural space that was not just described but could be experienced by the spectator as an almost physical substance.

<div style="margin-left:2em; float:left;">Marco Livingstone 'Mute Accomplices', Museum of Modern Art, Oxford 1987</div>

INTERIORS — WALL FURNITURE

Paintings tend to behave as windows, shelves or scenes, they can cut holes in the wall, establish ledges or like the television set, act as informative furniture. What each possibility does is to allow for the placing of an illusory 'view' within.

Very few paintings are made out-of-doors and even fewer are made to be viewed outside; for the painter there is a useful bond between the picture and the interior, which makes it a valuable setting for painters. If paintings are set indoors, metaphor can offer breadth, whilst the setting provides an opportunity for taking the viewer quite softly from the room into the picture.

Stephen Farthing 1988

Illustrated page 45

Michael Fussell

§ At the St Martins School of Art in the late '40s Michael Fussell was a charismatic personality, so intelligent, hyper-critical, vital in conversation and in his bearing and movements, to which his club foot gave a certain edge, a certain abruptness and set him just a little apart from the ordinary, the predictable. You noticed that handsome head of his with its quizzical, probing eyes, the tall, wide forehead from which the fair hair shot up a little before it condescended to settle, the humour of the mouth: it all suggested a certain energy, a certain sensitivity.

His student paintings were already distinguished by features that re-mained in all his later work; powers of simplification, of cutting back to the

bones of a statement and a sense of taut, pent-up energy that was derived from his sense of placing, weighting and from his rigorous drawing. After a period of expressionist painting in the early '50s, when he was much influenced by Soutine, Fussell "began to paint and draw the quite non-Expressionist, grave, dark, simple almost abstract 1955-56 still-lives that marked the beginning of his immediately recognisable originality as an artist" . . . "now the powers of simplification, the sense of space, the oppositions of tonal elements were all taken to their extreme limits. In sombre colour, clusters of objects were presented as if they were no longer the arbitrary units of design but rocks interrupting vast plains. At the same time the drawing was precise; left no doubt of the particularity of each garlic, each potato. In fact the strength of this new phase of the artist's work lay in his transformation of things seen; the elimination of all the immediate detail; the drama of very simple, very basic oppositions.

Lionel Miskin 'A Retrospective Exhibition of Paintings and Drawings', House Gallery, London 1976

William Gillies

Illustrated page 34

In still life I have felt able to go into almost pure abstraction; for in landscape there seemed a limit beyond which content vanished.

§ Gillies, however, has never aspired to an art completely isolated from everything . . . What he does, and does with surpassing elegance and decorative charm, is make "constructions which are completely self-consistent, self-supporting and self-contained — constructions which do not stand for something else, but appear to have an ultimate value, and in that sense to be real". These words of Roger Fry seem to me to be a perfect description of Gillies' still lifes, though they do not stress specifically their inherent lyricism and sensuous appeal . . .

Contrary to academic practice he has no need to set up 'groups' to work from; he is surrounded in his daily life by the very stuff of his art: to enter his studio, or, for that matter any room in his house at Temple, is to enter into his very existence. For Gillies paints still lifes because painting is his way of life, an affirmation of life and the ecstacies of pure experience.

William Gillies reported by T. Elder Dickson, see below

T. Elder Dickson 'W.G. Gillies', Scottish Arts Council, Edinburgh 1970

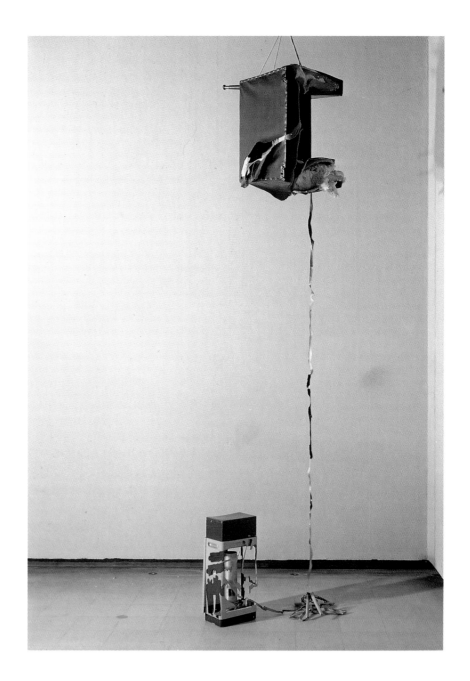

BILL WOODROW
*Armchair and Paraffin
Heater with Campfire* 1981

Antony Gormley

Illustrated page 51

Five Fishes is five objects each encased in a lead sheath. Lead is a material of transmutation and insulation; death to the object — a removal from site to be reborn in another place of the mind where differentiation has not occurred: "And the earth was without form and void; and darkness was upon the face of the deep" (Genesis, 1, 11).

This work abolishes time by removing objects from its flow and represents a moment of Adamic naming where evil coexists with good. The differentiations of matter occasioned by evolution and human intervention are reconciled in a formal phallic consistency that seems to make an unsteady balance between the peaceful and benign — the fish at one with its element and the vegetable, fruit of the "closed ground of the earth" — and the instruments of violence.

The invitation of this piece, as in the work from my body, is to allow consciousness to work anew on matter. And by denying the "creative" in its traditional artistic sense, to place the viewer in the same position as the artist in reinventing the world.

Antony Gormley, 1988

Duncan Grant

Illustrated page 31

§ There was a belief current after the first world war, and inherited, I suppose, from *art nouveau*, that the new design of things — from pottery, to rugs and tables and interior decoration would exercise a centripetal influence, finally changing the look of cities and countryside. This idea found expression in the Omega workshops run by Roger Fry.

So when one speaks of Duncan Grant as being decorative one really means more than the word implies. One means that he paints in a style which alters subject matter and material. One of his paintings hung on a wall, might leave the wall, cover tables, chairs, rugs and curtains with its curves and hatchings and colours. Ideally, it would be put in a room where there were patterns responsive to it. When one connects him with Bloomsbury one thinks of rooms in houses which are 'Duncan and Vanessa' and Omega.

There is something about such painting which is like mirrors reflecting interiors, and views seen from windows in such interiors, and one another.

Stephen Spender 'Duncan Grant
watercolours and drawings',
d'Offay Couper Gallery, London
1972

Duncan Grant paints a landscape, a still life, a nude, a Leda and the Swan. But he also — really or implicitly — paints the wall on which he hangs these, and then the chimney-piece, and then the woodwork of doors and windows and panelling. Moreover, he and Vanessa Bell design the rugs and also the pottery which are in the room. Then they paint other pictures which are of interiors of the room and its contents, nudes of people standing on rugs they have woven, views from these windows, even pictures and canvases which are themselves pictures of the room and its goings on.

Illustrated page 57

Tim Head

A city skyline
A synthetic landscape with consumer products
An accumulation of technological fall-out
A gloss of seductive surfaces
A conglomerate of objects that are merely signs
A cemetery of images
A techno-military-erotic-leisure complex
A new version of Piranesi's fictionalised 'Reconstruction of the Via Appia'
Or Richard Hamilton's lush, urbane images
(Vanitas)
Picture of a disposable present
A still life

Notes by Tim Head at the time of
making *The State of the Art*, 1984

The State of the Art was the first of Tim Head's large cibachrome photographs of artificial cityscapes or landscapes made out of manufactured objects. Its title refers not to art but to the current level of technology, in everything from hi-fi to defence equipment. The image is a grotesque parody of the modern city, the essential forms of which we see multiplied, without regard for scale, in gigantic skyscrapers and small, hand-held gadgets. Head has for years attended closely to the phenomena of the streets, and photographs he has taken of city spaces and shop windows served as source material for this picture.

As an artist, he is concerned neither with the subjective expresssion of 'private' experience, unrelated to power and property relations within our

culture, nor with a disembodied reading of the signs of mass-culture, detached from the actual experience of daily life. He finds the street to be the epitome of the public sphere, where each of us is an occasional passer-by but no one really belongs. There we can read the imagery of commerce in its proper context. The latest technological bric-a-brac appears behind glass in every High Street, in simple-minded, improvised arrangements, probably resembling the ways in which goods have been displayed in shop windows for centuries. Is this high-tech in primitive hands? *RM*

Tim Head recalls two notes by Marcel Duchamp which may be considered in relation to *The State of the Art*.

§ SPECULATIONS

Can one make works which are not works of "art"?

The question of shop windows . . .
To undergo the interrogation of shop windows . . .
The exigency of the shop window
The shop window proof of the existence of the outside world
When one undergoes the examination of the shop window one also
pronounces one's own sentence. In fact one's choice is "round trip."
From the demands of the shop windows, from the inevitable response
to shop windows, my choice is determined. No obstinacy, and the
absurdism of hiding the coition through a glass pane with one or many
objects of the shop window. The penalty consists in cutting the pane and in
feeling regret as soon as possession is consummated. Q.E.D.
Neuilly 1913

 1. Show case with sliding glass panes — place some fragile objects inside — inconvenience — narrowness — reduction of a space, ie way of being able to experiment in 3 dim. as one operates on planes in plane geometry — Placing on a table the largest number of fragile objects and of different shapes but without angles and standing upright on a level base of some width ie providing some stability — *Assemble as many objects as possible on the table in height* and consequently avoid the danger of their falling, of breaking them, — but

The White Box, 1967/8
Cordier & Ekstrom Gallery,
New York

nevertheless squeeze them together as much as possible so that they fit together one into the other (in height I mean) . . .

Perhaps; make a good photo of a table thus prepared, make *one* good print and then break the plate.

Illustrated page 18

Tim Head

In the subdued atmosphere of the University of Cambridge, where Tim Head was Kettle's Yard's Artist in Residence in 1978/9, he conceived a series of visual puzzles which, in a light-hearted spirit, overturned the principles of science and reason. Seeing Newton's original manuscript of the 'Principia' in the Wren Library at Trinity College prompted him to experiment with images which appeared to contradict the laws of gravity. He assembled a group of objects so that it could be read equally well upsidedown, then photographed it to actual size and inverted the photograph. By this simple act, gravity was converted into levity. The image, framed and hung on the wall, recalls the illusionism implicit in conventional picture display — the suspension of the picture so that it appears to float on the wall, its means of support concealed. *RM*

Illustrated page 35

Ivon Hitchens

§ Ivon Hitchens is a lone figure in contemporary British art . . . [he] simply does not qualify for the idiosyncratic categories of art which the English so much celebrate and honour . . . Hitchens appears as the true painter: instinctive, passionate, and sensuous. His communication resides not in any 'poetic' or symbolic interpretation of visual reality, but in the humble transcription, in terms of paint, of sensation itself.

There is no strong pulse in most English painting: its illustrative intricacy and formal irrelevancies do not conceal any firm abstract rhythm, any unifying configuration below the surface of the picture as it were. And colour is scarcely ever understood as the vibrant generator of space; but rather as a neat decorative or poetically emotive addition to a design, or to form, that is linear (or black and

white) in conception. English pictorial colour may be bright — and usually is, nowadays: but it is hardly ever luminous . . .

For Hitchens colour is light; and light is space.

. . . Hitchens confronts the visual scene every time he sets brush to canvas. This is a fact surprising to those who find his works difficult to read. In the more unexpected quarters one still encounters incredulity if one reveals that Hitchens goes out in all weathers to find his motif, and there pitch his easel, like any impressionist. Every statement he makes on the canvas is wrenched direct from Nature. The visual scene is always his point of departure: his sole data, the evidence of his eyes. He is thus an abstract painter in the true sense of the phrase; that is, he abstracts his pictorial configuration from visual reality direct. Starting by submitting himself to the infinitely complex, unanalysable texture of the visual scene — starting with perception — he forges his unique concepts in the teeth of Reality's assault upon his senses. To no other painter do Cézanne's precepts still apply more aptly: I mean that Hitchens may truly be said to be 'realizing his sensations before Nature', and not registering Nature herself (that is the realist's impossible dream), he achieves, not an imitation of natural appearances, but 'a harmony parallel to Nature'.

Patrick Heron 'Ivon Hitchens',
Quadrum, November 1956

Sharon Kivland

Illustrated page 38

Three Legs Good is an idea adapted from Kipling's 'Jungle Book' where Mowgli is warned that animals with four legs are good and those with two are dangerous. This title came before the piece itself. Writing about this and other work made at that time the artist has explained that:
Titles were important clues to their hidden meaning — sometimes they obscured rather than illuminated, as did some of the objects themselves — for example, lamps designed only to light themselves, unable to cast any light. They were jokes without a punch-line, like the image, punning and tongue in cheek; the way we speak when we are embarrassed, talking of things we are very serious about.

I loved the spindly optimism of the tables and plant racks; only just standing, elegantly balanced. I remember then I didn't want to talk about the work because these were things I loved and that the photographs made them impossibly beautiful

and inaccessible. I did not want them reincorporated into daily use by language. I wanted them to stay recognised but mysterious, out of use but glorified. Ikons, if you like . . . objects of love.

The objects were never intended to be seen as kitsch. They were retrieved and reconstructed from my post-war German childhood and thus might be symbols of optimism, representing aspects of a new order. In the fifties, art was incorporated into every aspect of design — from crockery to curtains — every pattern, colour or molecular plastic bobble referred to what would in Germany have at one time been called 'degenerate' art — the non-figurative exuberance of abstraction called upon to decorate the functional object.

Sharon Kivland, 1988

Marysia Lewandowska

Illustrated page 14

Marysia Lewandowska recalls, when considering the theme of this exhibition, that the first known photograph was a still-life subject, a table set for dinner, made by Niepce in around 1823. This reminds us that the pictorial conventions of photography are derived from painting, and Lewandowska perceives a close connection between the traditional still-life, in which a moment of inactivity is constructed, or staged, and the photographic 'still', itself a construction, a frozen moment, edited and disconnected from its origins.

Photographic enlargement takes the process of separating the image from its context further. In *Saw and Hair* the imagery is immediately recognisable, but like an emblematic still-life painting it also carries concealed meanings. Enlarged and isolated, dislocated by the shift in scale and the physical separation of its parts, it seems charged with an intense emotional and erotic significance. The artist speaks of the effect of enlargement in this work as *close to a kind of violation which acts here on a political level as a counter-representation to the dominant mode of representation of female sexuality.*

Saw and Hair was originally part of an installation of photographic transparencies entitled *The Missing Text*. Lewandowska describes her project as 'an enquiry into cultural signs which have been marginalised or displaced'. The body, as a metaphor for culture, can be 'read' as the text of history, a partial, fragmentary body, whose emphases and omissions reveal the power relations within the social and political spheres.

(Continued page 36)

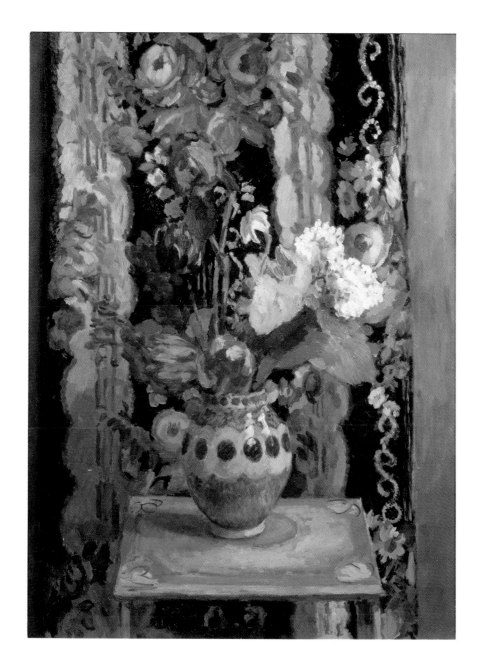

DUNCAN GRANT
Flowers against Chintz 1956

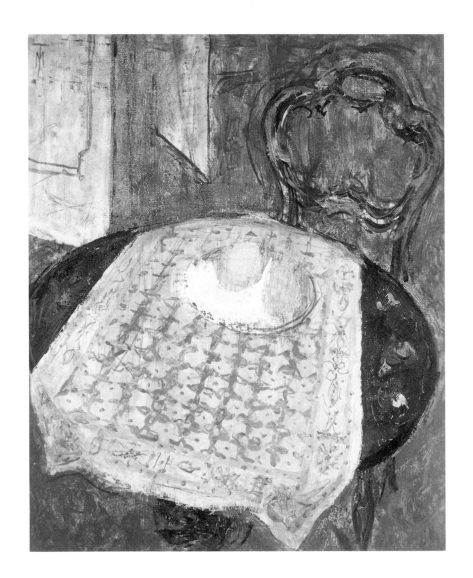

MARGARET THOMAS
The Chintz Tablecloth 1948

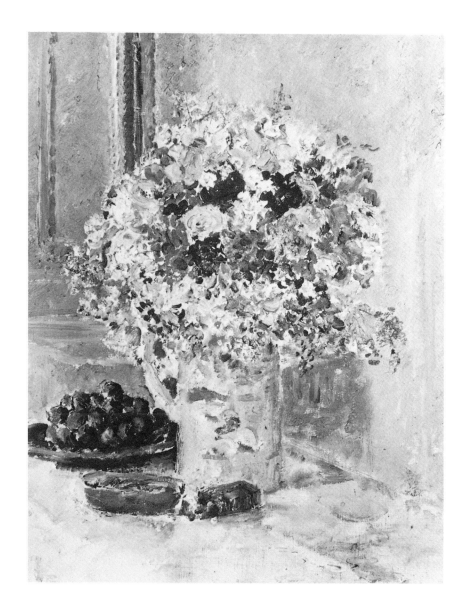

DAME ETHEL WALKER
Flowers and Grapes undated

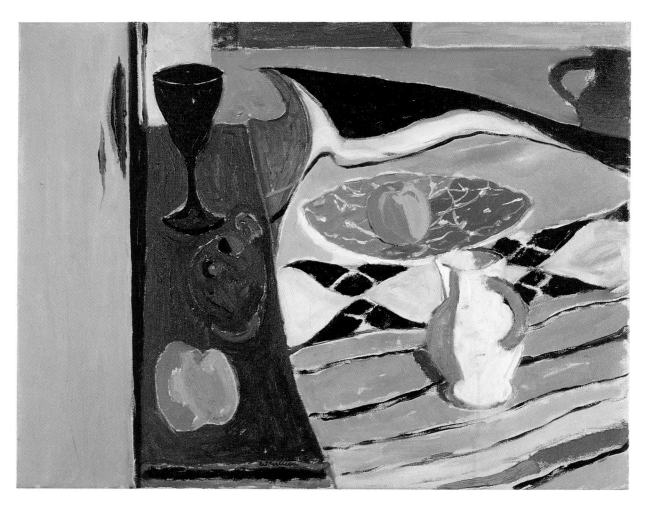

WILLIAM GILLIES
Still Life undated

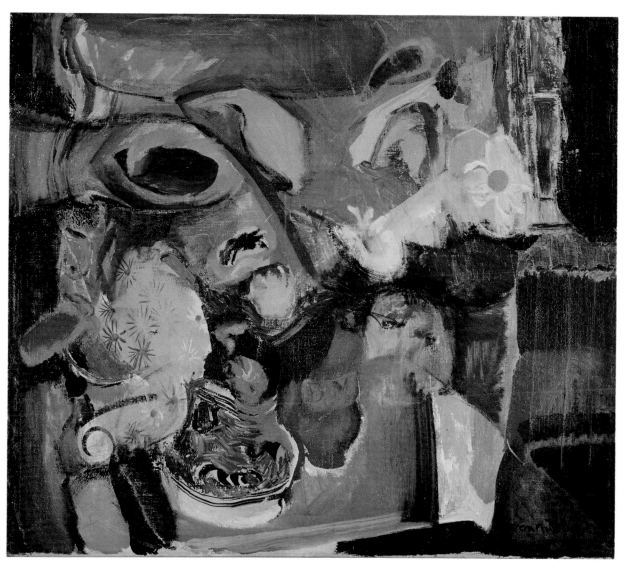

IVON HITCHENS
Flowers 1941

As a metaphor for displacement, the image evokes the lock of hair preserved as a memento of a missing person. The starkness of the confrontation between the saw and hair implies violence and sexual conflict; the fetishistic overtones invite a Freudian reading.

Lewandowska remains conscious of photography's relationship to painting, and the dominant role of the latter in the artistic hierarchy. This is evident in the way she presents the transparencies, stretched over simple wooden frames like canvases. By setting the work on the floor leaning lightly against the wall, she criticises painting's claim for the central position, preferring to remain outside its conventions. The choice of the transparency as the final form for the image signifies perhaps her wish to distance herself from photography's standard practices also, and to avoid the finality of professional packaging. The image is elusive, opaque when unilluminated, dependent on the source of light for its realisation. The fragile surface of the transparency is unprotected, its scale is that of the human body. The artist quotes Roland Barthes — "A sort of umbilical cord links the body of the photographed thing to my gaze: light, though impalpable, is here a carnal medium, a skin, I share with anyone who has been photographed."* *RM*

* Roland Barthes, 'Camera Lucida', Fontana, London 1982

Illustrated page 21

Di Livey

From about 1977 Di Livey began to use canvas stretched or folded over structures, then coated with layers of acrylic paint. *Domestic Piece One*, 1980, has a partner called *Domestic Piece Two* and is part of a series of sculptures based on tables in domestic situations.

My work reflects the confused and fragmented experience of my everyday life; from travelling, sitting in a gallery, wrapping a present or feeding the cat, all the time trying to hold onto the feeling of being separate. I like to think my work has a sense of isolation, but can also laugh at itself and become absurd.

Di Livey Serpentine Summer Show 2, London, Aug/Sept 1981

Leonard McComb

Illustrated page 41

§ McComb quotes with admiration some lines of William Blake:
For Art and Science cannot exist but in minutely
organised Particulars
And not in generalising Demonstrations of the
Rational Power
The Infinite alone resides in Definite and
Determinate Identity

At the centre of McComb's art lie many paradoxes. Indeed one of the sources of its power is the reconciliation within each work of qualities which in principle are opposites. Almost withdrawn in their lack of clamour, his images yet project themselves, with extraordinary and insistent authority. Conspicuous for its stillness, his art takes as central subject the vital and endless change of nature . . .

The more McComb defines the reality of nature the more he displays the contrivance of art — in itself a central subject, yet in his work made strangely one with nature's processes. *Imaginative truth is the only truth, and yet nature is all-powerful.* A northern and a Celtic artist, focussing on the particular, fascinated by rhythm and line, and giving his figures in many ways a vital awkwardness of presence that is part of their intensity, he yet looks always to the south, to the sun and to his also central theme of light, and seeks above all the rewards of control — a grand but also succinct unity between all his parts.

Reflective surfaces or the brilliance of paper can be expected to activate light, but in McComb's work it seems to be generated more dynamically . . . through an interweaving of accents which gives the emission of light an active pulse.

Richard Morphet 'Leonard McComb', Museum of Modern Art Oxford and the Arts Council of Great Britain, 1983

Alastair MacLennan

Illustrated page 59

§ Alastair MacLennan is best known for realising his ideas through 'Actuations' but concurrent with his live work he has also been drawing consistently as a parallel and integral process of developing images and themes. The drawings

(Continued page 43)

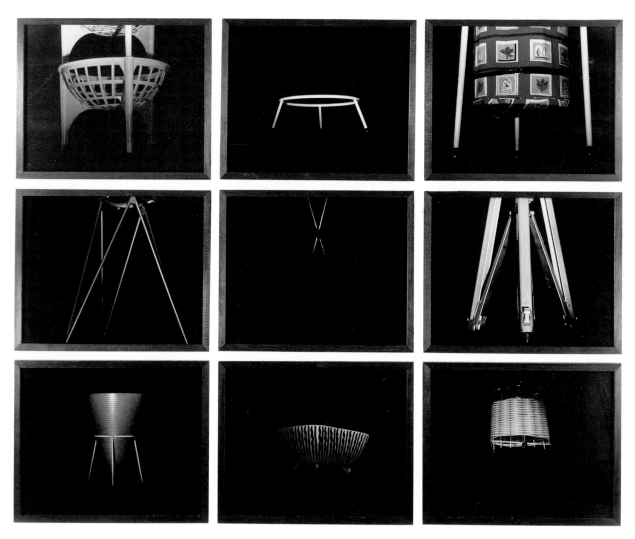

SHARON KIVLAND
Three Legs Good 1982

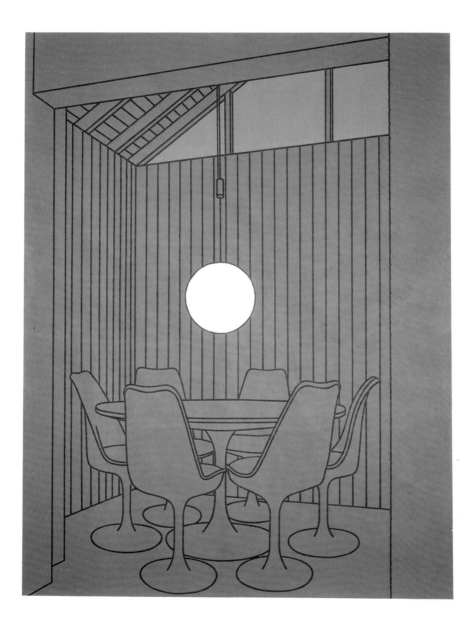

PATRICK CAULFIELD
Dining Recess 1972

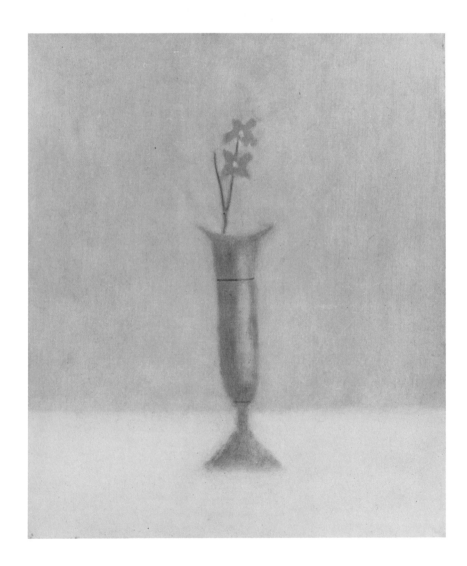

CRAIGIE AITCHISON
Grey Vase: Still Life 1965

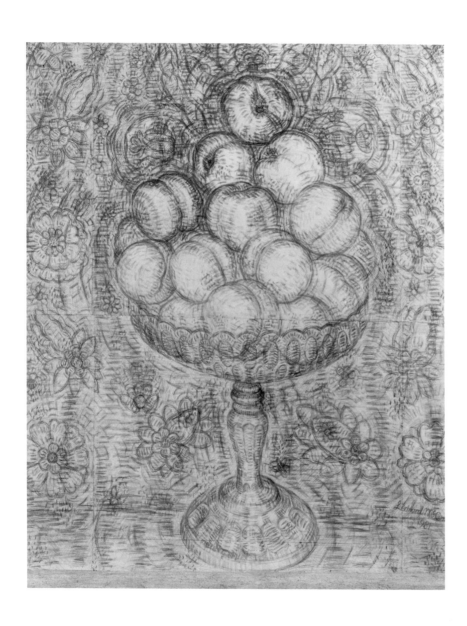

LEONARD McCOMB
Peaches in a Glass Stand 1982

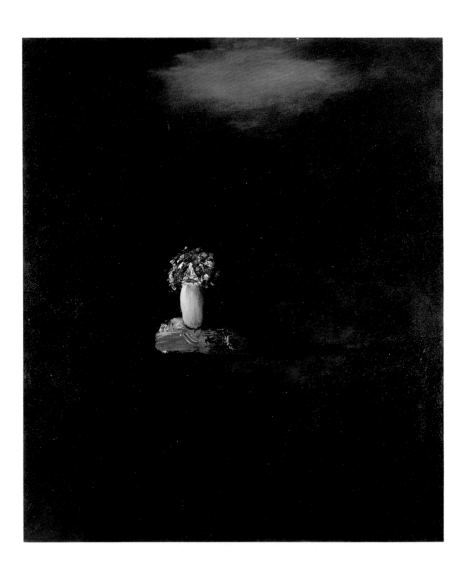

ANDREW MANSFIELD
Nature Morte 1985

can be seen as extensions and developments from the performance and they also stand as completions in their own right.

Drawing presents itself with immediacy and intimacy. It is an original document of the doer's act . . . an external image of a private thought, not distanced by theory, necessarily but close and inseparable from the author's psyche.

Mass media reportage of events in Northern Ireland has its inadequacies of sensationalism and an over-simplistic approach, which reinforces outsiders' pre-conditioned perceptions of the province. For MacLennan issues are not so clear cut. Insensitive divisions are anathema to him. It is in his nature and humanity to communicate a more comprehensively realised experience. One-sided rhetoric he finds abhorrent. His studio is in the heart of East Belfast. It is a typical working class area with the ubiquitous, easily accessible, all purpose shopping centre round the corner. The streets bear the marks of economic, political and social strife. Religious iconography signifies tribal boundaries. In it, he is not of it.

. . . Collecting and assembling emblems and signifiers (Doctor Martens, dolls, sunglasses, outlines of Northern Ireland and Ireland, batons, mushroom clouds, gloves, false teeth, skulls, ladders, bowler hats, nail bombs, masks etc.) from his environment, is not facile contrivance . . .

. . . This visual archive from everyday life serves as a warning not to pass over human tragedy. The drawings are a diary of conditions which reveal a landscape of ruins, human disregard and conscious 'blindness'.

Stephen Snoddy 'Alastair MacLennan, *Is No*, 1975-1988', Arnolfini, Bristol 1988

Andrew Mansfield

Illustrated page 42

The title *Nature Morte*, the French expression for still life (literally 'dead nature'), emphasises the transience of the beauty of cut flowers. There is irony also because the painting so radiates life and, instead of sitting in a man-made interior, the bowl of flowers has been placed in a vast moonlit landscape, a combination of elements that hint at feminine mysteries. *IJ*

§ . . . in approaching paintings like these we are dealing with a presence much like that of a person in a portrait. We feel confronted by another, by a mood and a character. A painting can be a fictive mirror on which is projected that other

Tony Godfrey 'Landscape, Memory
and Desire', Serpentine Gallery,
London 1984

within ourselves, or some element of ourselves, some object of desire. By painting, or looking at painting, we are calling into question our own nature, our own status as subject. Here painting is not escapist: it neither soothes, nor comforts, but addresses us, questions us.

Illustrated page 49

Ben Nicholson

§ In the first place, a peculiarity of the exhibition lies in the sense of age . . . we have the feeling of things weathered and beautifully worn. They have all the charm of old walls or pavements stained and scoured, encrusted with exquisite lichens, enriched by curious and delicate patina.

. . . the paintings of Ben Nicholson . . . make their own terms with the spectator, who will not find in them a vehicle for sentiments. These paintings, . . . exist by virtue of themselves; their life depends upon every plane and tone, every line and spot, the very vibration of their surface is their breath. What they presume to represent is negligible; a doubtful collection of mugs and jugs, mythical fish or deformed musical instruments, all equally useless for drink, food, or music. Yet from this curious junk is distilled beauty . . . What known or unknown experience of our nature is touched upon by such paintings needs close analysis to explain, but there is no denying their sensuous appeal. Each is alive with a physical and mental charm, part instinctive, part infinitely calculated.

Paul Nash, reviewing an exhibition
of carvings by Barbara Hepworth
and paintings by Ben Nicholson at
Arthur Tooth's Galleries, 'The
Week-End Review', 19 November
1932

In writing Herbert [Read] recently a letter which I did not in the end post, I found myself putting out an idea that what I am interested in painting is in realising an experience and not at all in making a painting. It's something to do with creating an enduring reality based on an experience of living which is by no means purely visual but is a rhythm arrived at by means of all the senses.

In my work I don't want to achieve a dramatic arresting experience exciting as that can be, but something more enduring — the kind of thing one finds say in the finest Chinese vases or in the Cézanne apple paintings.

If you love someone or hate them, the smallest fraction of them is felt by all the senses and instantly conjures up that 'love' or 'hate' feeling and a single line on a piece of paper can do the same. The interesting thing is to resolve an experience in paint until it becomes purely mental — that is to say, it is apparently impossible to touch the surface of the painting because it is no longer a physical paint-surface but

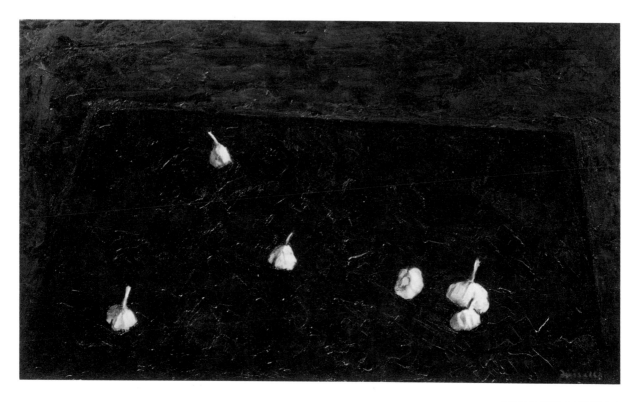

MICHAEL FUSSELL
Garlic c1956

an idea.

Another point in reference to the too-easy humanistic or dramatic approach to painting and sculpture especially prevalent in London today, is that one can make say a couple of bottle forms alive up to a point and in an instant by the insertion of an 'eye' as a 'life-point' but to achieve this 'life' by a resolution of the same forms as one whole and without this 'easy' life point is a profound problem and when solved the more enduring, I believe ... But, in order to contradict myself, a little at any rate, the kind of aliveness that comes with an eye can also be profound as it is when innumerable 'eyes' unfold in a Picasso when they are resolved and become with his immense vitality — as in the 'Nu couche et femme assise à la mandoline' — eyes within eyes!

Extract from letter to Lilian Somerville, 25/26 March 1954 in 'Ben Nicholson', A Studio International Special 1969

Illustrated page 56

Ron O'Donnell

The brevity of human existence is often the deeper meaning underlying still-lifes of simple objects, a skull or a lighted candle for example, which signify decay and the passing of time. In *The Antechamber of Rameses IV in the Valley of the Kings* Ron O'Donnell has created and photographed an environment closer to a horror movie than a traditional 'Vanitas' painting. His initial idea indeed came from a film, Fellini's 'Roma', where workers constructing a tunnel stumble upon a large room with Roman frescoes that start to decompose and disappear as they come in contact with the outside air.

It is not clear here whether the wallpaper is decaying to reveal Egyptian tomb paintings or whether the tawdry traces of a more recent past are about to vanish. The lit lamp, abandoned shoes, mug and empty armchair indicate occupancy, and the newspaper with its headline 'Huge bill ahead for housing' strikes a wry note of social concern. A mysterious light floods from the open sideboard to reveal a slice of bread. Could a downwardly mobile member of today's society have chosen to make his exit from the twentieth century and been lured back in time and place? *IJ*

Carl Plackman

Illustrated page 58

§ What exactly is Plackman's medium? He draws, and he shapes and arranges objects of many sorts, so professionally, his medium is graphic and sculptural in turn. Beyond that, though, he seems to me linked also to another artistic sphere, and my use of the word 'tableaux' has hinted at it: theatre, performance. The more one stays with his work, the more one ponders it, the more it suggests a kind of action, an enactment. There is no performer, unless it is ourselves engaging with his symbolical stage props, studying this part or that, returning to the whole, connecting our experience of life to the signals before us, penetrating and possessing the environmental stage. In this sense his medium is drama — and that means time as much as forms and space. And his message? More than another modern sculpture, Plackman's has discursive content. With his guidance one might write much of it out, or, better, he could do it for us (he is finely, selectively literate). His titles are there to set us off . . ."

Wardrobe seems a strange association to be asked to bring to forms made from these untidy, potentially dusty and oozing natural surfaces. A wardrobe is usually a solid and reassuring object concealing and protecting clothes which in turn protect us. This wardrobe has the untidy rawness of something more internal. The artist and his wife were expecting their first child when the sculpture was conceived and this knowledge does help to unravel its possible content — the balance of male and female elements, perched parrots (or are they woolly hats?), cradle, umbilical cord, dangling toys. *IJ*

Norbert Lynton 'Arnolfini Review', Nov/Dec 1978

William Scott

Illustrated page 53

I was brought up in a grey world, an austere world: the garden I knew was a cemetery and we had no fine furniture. The objects I painted were the symbols of the life I knew best and the pictures which looked most like mine were painted on walls a thousand years ago. I may begin a picture as a careful recording of a special sensation evoked clearly at a remembered time and place, and by a continuous process of work, obliteration, change, an expression of an entirely different thing grows, a 'figure into landscape' or into a still life, 'a man into a woman'. I have no theory. I am not concerned only with 'space construction'. What matters to me in a

William Scott, from 'Nine Abstract Artists', by Lawrence Alloway, Tiranti, London 1954

picture is the 'indefinable'.

Sometimes the object disappears and takes on a new meaning. It is during this moment of transition when I feel I realise most completely my intentions. Apart from the subject, which I can do nothing about, what interests me in the beginning of a picture is the division of spaces and forms; these must be made to move and animated like living matter. I have a strong preference for primitive and elementary forms and I should like to combine a sensual eroticism with a starkness which will be instinctive and uncontrived. To have a too clearly conceived idea before beginning a work is for me a constriction; it is in the act of making that the subject takes form, it is in the adding, stretching, taking away and searching for the right and exact statement that a tension is set up. I want to paint what I see but never immediately; there must be a time lapse, 'a waiting time' for the visual experience to become involved with all other experience. That is why I paint from memory.

§ Scott once called still life 'My chief occupation'. It is of course the most abstract and timeless genre of painting, the most free of literary associations, the most apt for a painter now learning to exploit pictorial space composition. At this moment Scott chanced to see in Paris an exhibition called 'A Thousand Years of Still Life Painting': 'I was really overwhelmed by the fact that the subject had hardly changed for a thousand years, and yet each generation in turn expressed its own period and feelings and time within this terribly limited narrow range of the still life'.

The crucial painting of 1946, full of future possibilities, is *The Frying Pan*. Nothing could be plainer and more empty, and yet everything is exactly placed to give a dignity and resonance to the whole composition. The forms are beginning to be flattened, pointing the direction in which Scott's work is to go. The elements themselves are of the simplest — an earthenware bowl, a black frying pan, an iron toasting fork, a white cloth, a bare kitchen table. They are all old country objects, known to Scott from childhood, and permanently familiar. Though he always painted from memory and not from the objects themselves, some were in fact hanging on the walls of his studio at Hallatrow where he worked.

William Scott 'The New Decade',
Museum of Modern Art, New York
1955

Alan Bowness 'William Scott',
Lund Humphries, London 1964

(Continued page 61)

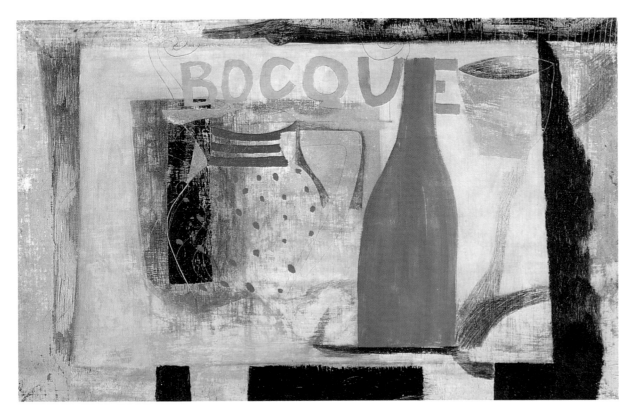

BEN NICHOLSON
Bocque 1932

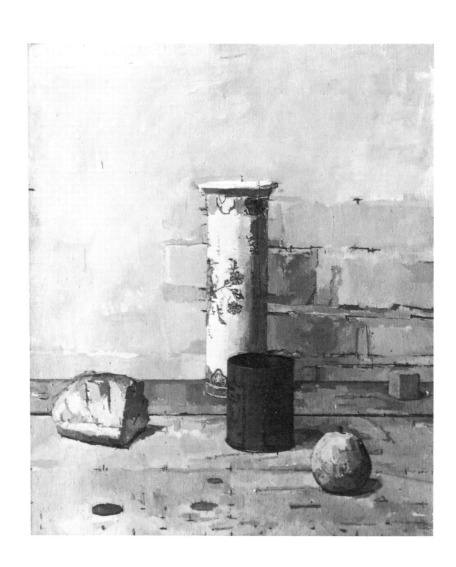

EUAN UGLOW
Still Life with Delft Jar 1958

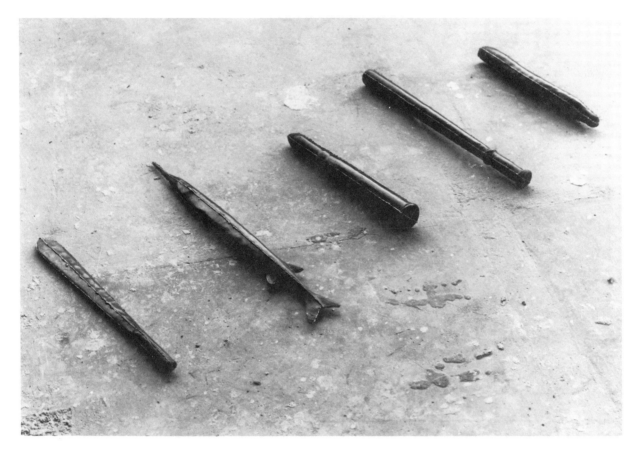

ANTONY GORMLEY
Five Fishes 1982

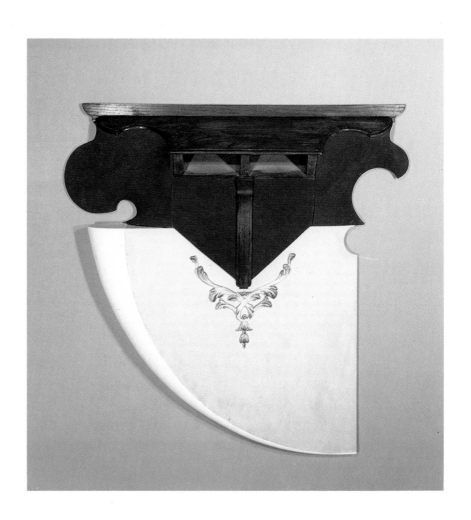

GERARD WILLIAMS
Console 1987/88

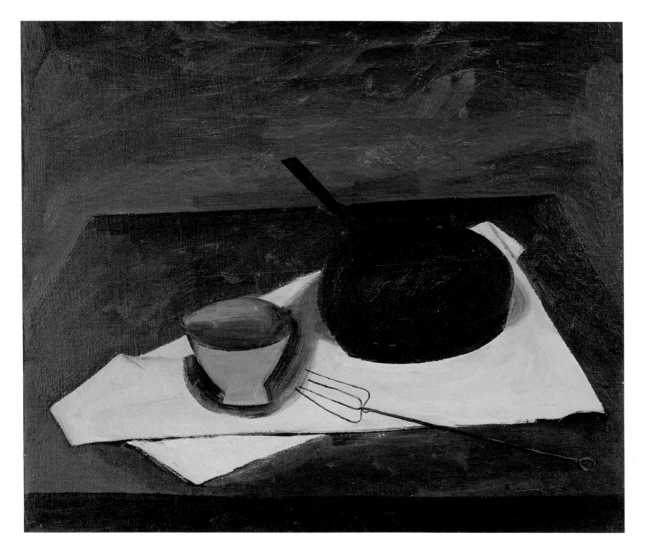

WILLIAM SCOTT
The Frying Pan 1946

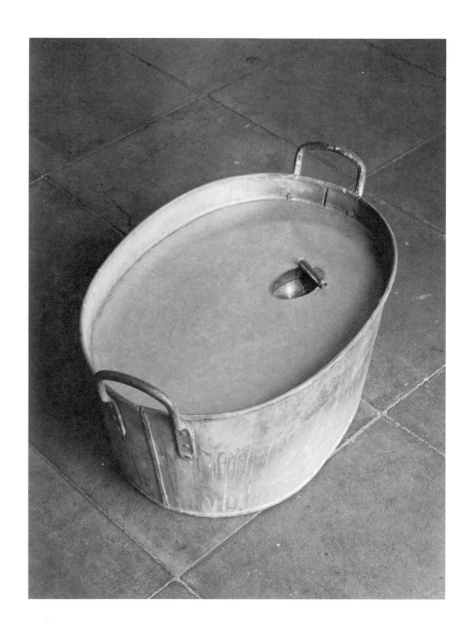

RICHARD WENTWORTH
Toy 1983

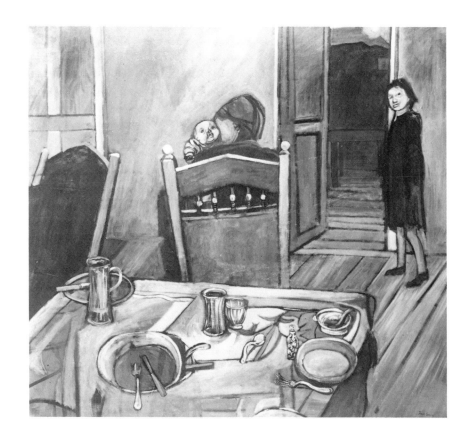

JACK SMITH
After the Meal 1952

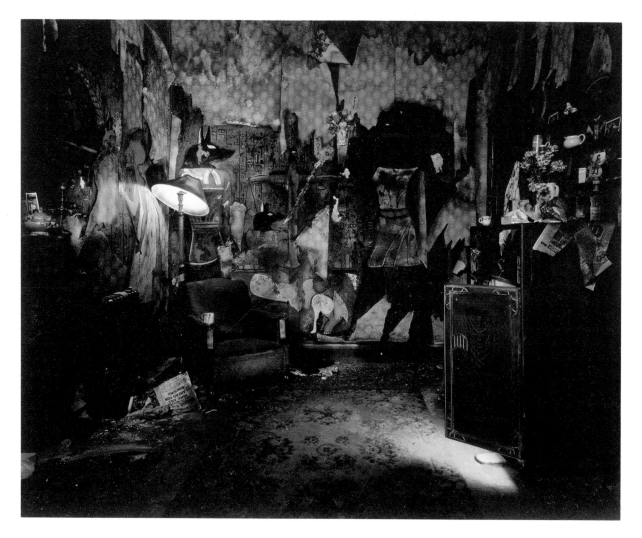

RON O'DONNELL
The Antechamber of
Rameses IV in the Valley of the
Kings 1985

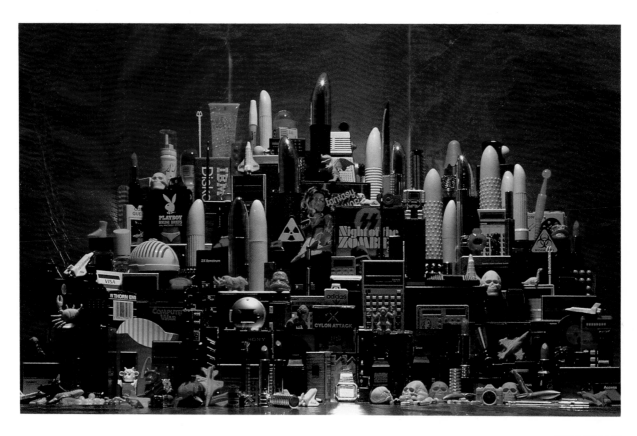

TIM HEAD
The State of the Art 1984

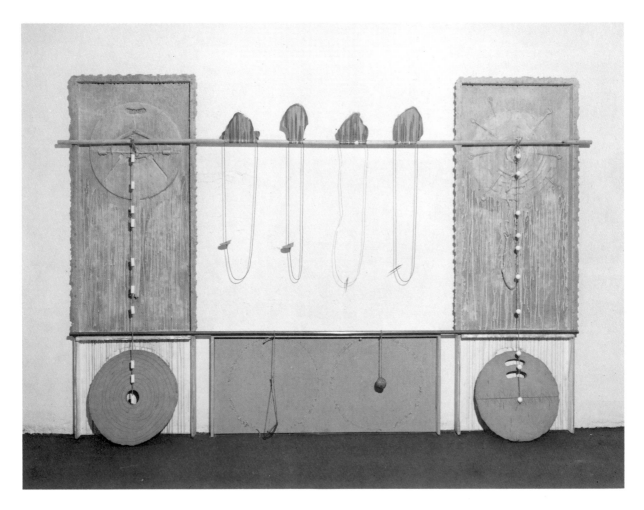

CARL PLACKMAN
Wardrobe 1980

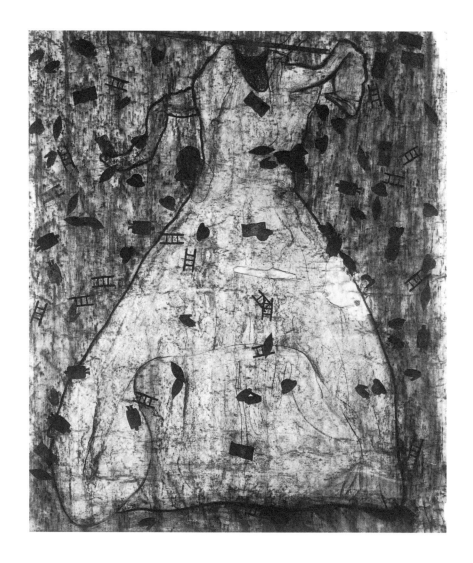

ALASTAIR MacLENNAN
Drawing from 'The On' series
1988

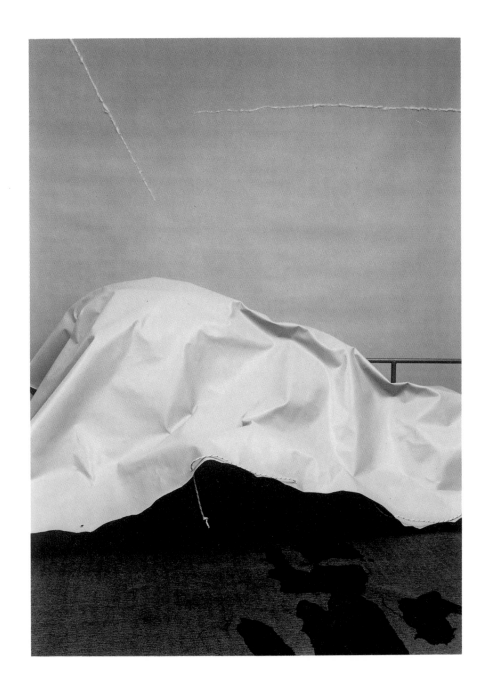

BOYD WEBB
Murmansk 1981

Geoffrey Smedley

Illustrated page 15

The Solids *came from a group of works (including some of a larger and more complex kind) which share similar preoccupations. I remember dwelling on the connection between the identity of things and the nature of representation. On how fragile endurance is in the face of the experience of change — and how dependent on memory.*

Somehow, it is pictures repeated, and represented which turn events into objects. Lucretius in his account of optics suggested that the air is full of images. But my reverie was less scientific, more psychological: I felt the force of Symond's almost Elizabethan rendering of Michelangelo's inversion: Myself am ever mine own counterfeit.

I have long been interested in classical geometry, and fascinated by the Timaean solids. In Plato's imagination they are pictures of what endures in the physical world: they are the archetypes of form. But there are other archetypes, those of mood for instance. One can sense them in the artifacts handed down to us: they have been sustained by acts of memory and bring nostalgia and melancholy in their train. Indeed sadness is discernible in any still object. It is in this perspective that I see sculpture: it is essentially a memorial art.

Among the Bicameral Solids *is an italic ogee form. I intended it as a mnemonic for all leaning things and their pendant moods. And so with the other pieces: in them I have attempted to depict further divisions of melancholy.*

Geoffrey Smedley, Vancouver,
September 1988

Jack Smith

Illustrated page 55

In 1954 the young critic David Sylvester reviewed an exhibition of the work of John Bratby, Derrick Greaves, Edward Middleditch and Jack Smith and inadvertently named a new school.

§ The post-war generation takes us back from the studio to the kitchen. Dead ducks, rabbits and fish — especially skate — can be found there, as in the expressionist slaughterhouse, but only as part of an inventory which includes every kind of food and drink, every kind of utensil and implement, the usual plain furniture, and even the baby's nappies on the line. Everything but the kitchen sink? The kitchen sink too.

David Sylvester 'The Kitchen Sink',
'Encounter', 1954

§ . . . the Zeitgeist of the post-war era . . . was expressed in what Bratby has called 'the colour and mood of ration books — the general feeling of sackcloth and ashes after the war'. The prevalence of drab biscuit colours is one of the most striking family likenesses among figurative art of the period. Jack Smith attributed this more to economics than preference; it was simply that earth pigments, like yellow ochre, were the cheapest colours available.

The Art of the 1940s in France and England didn't excite me. I reacted against its lack of creative and inventive energy. So, like many artists before me I turned to my own environment for subject matter. Out of that chaos I tried to establish visual order, to establish some kind of rapport between a person and the objects which surround them. The objects became part of the human struggle, reflecting anxieties and tribulations. I wanted to make the ordinary miraculous. This has nothing to do with social comment. If I had painted in a palace I would have painted the chandeliers.

Julian Spalding 'The Forgotten Fifties', Graves Art Gallery, Sheffield 1984

Jack Smith, December 1983, 'The Forgotten Fifties', ibid.

Illustrated page 32

Margaret Thomas

A drawing room still-life whose luminous tonality and controlled arrangement show a Whistlerian restraint that is gently activated by the flourish of the chair back and the patterned cloth. *IJ*

Illustrated page 16

Suzanne Treister

The densely packed spines of books give structure to the picture and create an illusion of weight and depth. The miniature interior at the centre offers a vanishing-point; it is like a snug private library, daintily furnished, a fragile defence against the void. Books closed and stacked or shelved are mute objects of furniture, but opened they can speak, revealing, perhaps, terrible truths. The open mouths denote terror — one the roar of nature, the other a cry of fear — and the storm-laden clouds suggest another sound, the crash of thunder. The paradoxical play of inner and outer, open and shut, sounds and silence, give a conceptual twist to this Hammer-horror atmosphere: the 'holes' in the canvas,

the windows which open onto illusionistic space, are pictures framed but also denied, fictionalised, by the flat surface of the wall of books. *RM*

Belief is gained and lost again inside the painting. I have built no parameters around the questions I approach. I want to set up a structure which can support various ideas; a construction to initiate a thinking, questioning process, also allowing for intuitive associative responses, frozen composite 'stills' with no 'fixed' meaning. A reconciliation of the sublime/spiritual/religious, with the banal/ridiculous/irreverent. Belief and cynicism, subversion and nostalgia. Out of the inconsistencies inevitably existent in our lives I would like to make something beautiful, cruel and humourous, to force them into relationships with one another.

Suzanne Treister, notes from a sketchbook, 1988

Euan Uglow

Illustrated page 50

§ The position of things is searched for on vertical and horizontal co-ordinates. Each line and shape as it is measured is detached from its environment and in its movement to the eye is projected and flattened on to the picture plane. Each assessment reaffirms the existence of this plane and of course the surface of the canvas of which it is a momentary substitute. The drawing reveals the form and that same drawing manipulates the shape so that the form is at its clearest and fullest.

If Bertrand Russell could remark, '. . . I believe partly by a study of syntax we can arrive at a considerable knowledge concerning the world', then the reverse is true. That is, in the attempt to come to terms with the world he sees the painter does arrive at a syntax: the order and structure of the paint itself across the canvas . . .

These intensely serious paintings . . . are extreme. The extreme devotion to the image is watched by an equal concern for the language of art, as if they provide a necessary challenge to each other in bringing the paintings to their intensity and high pitch . . . The motifs are often traditional, and the sternness of enquiry, and the sensuousness of the physical presence give the paintings some affinity with the long line of French paintings from Poussin to Léger. But in the examination and declaration of procedures as things in themselves, in the emphasis on language, they can only belong to today.

Myles Murphy 'Euan Uglow', Whitechapel Art Gallery, Arts Council of Great Britain, London 1974

Ethel Walker

Illustrated page 33

Ethel Walker was elected a member of the New English Art Club in 1900 and became one of the foremost women painters in Britain to develop an impressionist technique. This study was probably made near the date of purchase, 1942, late in her career. It shows a characteristic grace and lightness of touch, and a use of colour and tone that gives maximum luminosity to a simple subject. *IJ*

Boyd Webb

Illustrated page 60

Stuart Morgan 'Boyd Webb', Whitechapel Art Gallery, London 1987

§ No name exists for the genre Webb has perfected. Though the product is a cibachrome photograph, 'photography' in most senses of the word cannot accommodate the fact that he constructs what he then records. He is more than a sculptor who simply documents his work. Without the framing, the flattening, the sheer 'otherness' of the world seen through a viewfinder, his art could be written off as eccentricity, the hobby of an oddball with a perverse attitude to materials. In fact, his basic gesture — the making, photographing and destruction of flimsy, purpose-built sets — constitutes a critique of both photography and sculpture at the same time.
A critique, too, of our own time where photography usually glorifies the fabric of our consumer society. Boyd Webb questions life as we know it and see it, and invites the viewer to unravel an impossible narrative which nonetheless, like life itself, appears to have some logic.
Title, tarpaulin, the riven sky's hand rail suggest a grey voyage to a remote place. But the patches of water on the deck surely signify something more sinister than a drying cloudburst? *IJ*

Richard Wentworth

Illustrated page 54

For over fifteen years Richard Wentworth has been photographing real life situations that he describes as 'Making Do & Getting By'. These show a

persistent human tendency to be inventive under often trivial circumstances.

*We become accustomed to natural patterns — the door and its doormat. When their positions are disrupted something fundamental happens (commonplaces such as the ruck-and-jam method of holding open a door with a mat). The displaced doormat has a new identity, a shift of an inch or two changes it from passive to active. Such adjustments invigorate tired and overlooked relationships, as the contradiction, humour and absurdity of the new alliance presents itself.**

Hitherto passive objects begin to play positive roles. This ingenuity applied to ordinary life has its counterpart in Richard Wentworth's own work. Often humble objects are subjected to modest adjustments. In *Toy* a galvanised tub has a sardine tin inserted into a metal surface, like a battleship on an ocean. *IJ*

*Toy was made when my children were very young; at a time when the debate about the Falklands was still a public matter. Like songs and poems the sculpture uses rhymes, illusions and references. Like our lives, the sculpture appears precarious. Is the tin floating or sinking? Also like our lives it is pessimistic and yet optimistic — appearing absurd one minute, serious the next.***

The scale of these works is generally small. This is not simply because domestic items often constitute the starting point. Wentworth argues that we get to know the world through touch, through handling and manipulating objects. Moreover it is in the apparently trivial and commonplace that much of worth lies. Most of us display creative and imaginative capacities in these incidental areas rather than in the so-called major areas of life where we are often passive, merely reflecting or reacting to stereotypes. In such minor episodes and situations often a poetic resonance as well as a display of ingenuity and inventiveness is involved. Such situations cannot easily be the stuff of an art that is heroic, monumental or tragic — but art that aspires to be of this kind too often now looks rhetorical or empty.

Since his works more often arouse a sense of delight than of forthright humour, it is worth recalling Freud's notion that humour is often employed to fend off suffering: 'Humour is not resigned: it is rebellious. It signifies not only the triumph of the ego but also of the pleasure principle, which is here to assert itself against the unkindness of real circumstances'."***

* Richard Wentworth, Tate Gallery Publication, 1984

** Richard Wentworth, August 1984 (statement made during the 'Home and Abroad' exhibition at the Serpentine Gallery)

*** Lynne Cooke 'Richard Wentworth', Lisson Gallery, London 1984

Illustrated page 52

Gerard Williams

A place invented in the remembered dream of a fictional woman

It seemed as if I was calling in to meet someone on my way elsewhere. I was heading purposefully towards an immaculate, neo-classical wedding cake of a building, on the edge of what appeared to be Regents Park. The entryphone was answered immediately: a woman's voice, metallic, slightly crackly. I replied with a name, the latch buzzed and I was standing in a silent carpeted hallway.

After waiting there for a little while and looking around, I thought it best to call out, but the sound was muffled, lost. I had supposed that whoever I was meeting lived here, but this house didn't feel as if it was home to anyone. I started to move quickly through several warm, decorative, very still rooms. I realised that I wasn't going to find anyone easily, and began to feel as if I'd made some mistake, so I decided that the best thing would be just to slip out: I had started to feel like an intruder. Hesitating then, one foot outside, I knew I should be telling someone that I was leaving, but I shook the impulse off and let the door close behind me.

The feeling now was of a kind of release, but from a place that had never really held me. Walking away, I glanced back and was touched by a slight shiver of panic — had I left something behind? I realised almost immediately it was more complicated than that, and strange to have to accept. I felt as if I had inadvertently taken away something that belonged to the house, but which, rather than stolen had been hidden about my person, it was of no value to me. This had been substituted, in a kind of natural exchange, for something that I had missed of myself: that was what had been left behind."

Gerard Williams, December 1988

Illustrated page 13

Victor Willing

Place of Exile is an early example from a series of drawings begun by Victor Willing in July 1976, from hallucinations seen in a state of reverie. Several of these were worked up into large paintings. He named the study *Place of Exile*, referring to his life in Portugal from 1957 until revolution forced his return to England in 1974.

Many of the studies made between 1976 and 1980 are of uninhabited

spaces littered with fragments, objects and clothing. This drawing is one of few to contain a figure. Two months later in another study of the same subject the artist's dog disappeared and his form became a ghostly trace. In the large painting *Place* of 1976-78, which is based on these drawings, there is no figure at all, only an empty chair. Perhaps the most famous use of this device was by van Gogh, whose separate paintings of his own chair and that of Gaugin so powerfully signified the presence of their different characters.

The little shelter or open stage in *Place of Exile* is one of several confining spaces referred to by the artist (in retrospect) as *images of self-containment*, inhibitors of physical activity conducive to the concentration of mental energies. These he compared, in a conversation with John McEwan, to a monk in his cell feeling that he was bringing his disparate self down to a hard core.*

* 'Victor Willing', Whitechapel Art Gallery, London 1986

An outline border is a feature of all these drawings, a device Lynne Cooke has observed: "Remiscent of Giacometti's practice, it serves a dual function for Willing, bringing the image up onto the surface of the page, and indicating that the world portrayed within is a construct, a vision. The counterpart in the paintings is the way in which the coloured grounds do not always fill the whole surface, the uneven edges suggesting the coming-into-being of the whole as image".**

** ibid

The irrational genesis of these images naturally led the artist to speculate upon meanings and to devise titles. If *Place of Exile* shows him in Portugal, he still appears to be at one with nature. The ladder and open box suggest unease, perhaps hinting at the more structured and ambitious life he had left behind in London. The impression of natural harmony conveyed by the plant on the right assumes a sinister dimension only when he later recalled Jonah's dream of the worm which kills the tree that provided him with shelter. *IJ*

Bill Woodrow

Illustrated page 24

§ Seldom does one object metamorphose into another in such a way and to such a degree that it is totally transformed . . . it is a dialogue *between* two objects which exist at the same moment in time which is central to Woodrow's approach, a dialogue which depends upon the fact of co-existence. This in turn distinguishes him from the surrealists and their progeny who attempted through

juxtaposition to effect a new reality, one that is comparable in its convulsive haunting beauty to the imaginings of the unfettered unconscious as manifest in dream and fantasy. Unlike the surrealists Woodrow's work engages with the present and the actual. He does not point to an alternative and preferred order of existence, elsewhere.

In 1982, Bill Woodrow's sculptures were like tableaux relating narratives of crime and violence. *Armchair and Paraffin Heater* is earlier in date but the menace of incipient disaster, or disaster in progress, connects it to these pieces although the coolness of the 'film noir' atmosphere that sometimes prevails is here banished by the boy scout connotations of the camp fire.

As Lynne Cooke has observed, many works made in 1981 rely on binary relationships, sometimes pairing by analogy — the paraffin heater creates warmth as does a camp fire. The vulture-like suspension of the armchair is less clear. Its shredded skin becomes the smoke of the fire. Hovering in the viewer's mind might also be the threat of fumes that are such a hazard of burning synthetics. *IJ*

Lynne Cooke 'Bill Woodrow Sculpture 1980-86', The Fruitmarket Gallery, Edinburgh 1986

List of works

Craigie Aitchison
Born in Scotland 1926,
lives and works in London
Grey Vase: Still Life 1965
Oil on canvas
29.5 x 25.1 cm
Bought 1966
(Text p.10 Illus. p.40)

Patrick Caulfield
Born in London 1936,
lives and works in London
Dining Recess 1972
Oil on canvas
274.5 x 213.5 cm
Bought 1974
(Text p.10 Illus. p.39)

Michael Craig-Martin
Born in Dublin 1941,
lives and works in London
Painting and Picturing 1978
Oil and tape on canvas
214 x 165.9 cm
Bought 1979
(Text p.11 Illus. p.19)

Cathy de Monchaux
Born 1960,
lives and works in London
Ferment 1988
Lead, velvet and bolts
24 x 168 x 16 cm
Bought 1988
(Text p.12 Illus p.20)

Stephen Farthing
Born in London 1950,
lives and works in Sussex
Mrs G's Chair 1982
Encaustic on cotton duck
165 x 269 cm
Bought 1983
(Text p.12 Illus. p.17)

Michael Fussell
Born in Southampton 1927,
died 1974
Garlic c1956
Oil on canvas
75.5 x 127 cm
Bought 1955
(Text p.22 Illus. p45)

William Gillies
Born in Haddington, East Lothian,
died 1973
Still Life undated
Oil on canvas
58.4 x 78.7 cm
Bought 1955
(Text p.23 Illus. p.34)

Antony Gormley
Born in London 1950,
lives and works in London
Five Fishes 1982
Lead
7 x 70 x 200 cm approx
Bought 1982
(Text p.25 Illus. p.51)

Duncan Grant
Born in Rothiemurchus,
Invernesshire 1885, died 1978
Flowers against Chintz 1956
Oil on board
75.8 x 54.9 cm
Bought 1957
(Text p.25 Illus. p.31)

Tim Head
Born in London 1946,
lives and works in London
Levity I 1978
Black and white photograph
118 x 120.5 cm
Bought 1978
(Text p.28 Illus. p.18)

Tim Head
The State of the Art 1984
Colour photograph
183 x 274 cm
Bought 1984
(Text p.26 Illus. p.57)

Ivon Hitchens
Born in London 1893, died 1979
Flowers 1941
Oil on canvas
63.5 x 73.7 cm
Bought 1942
(Text p.20 Illus. p.35)

Sharon Kivland
Born in Germany 1955,
lives and works in London
Three Legs Good 1982
9 unique colour photographs
125 x 155 cm
Bought 1982
(Text p.29 Illus. p.38)

Marysia Lewandowska
Born in Poland 1955,
lives and works in London
The Missing Text: Saw and Hair
1988
Black and white photographic
transparency
200 x 61 x 7.5 cm
Bought 1988
(Text p.30 Illus. p.14)

Di Livey
Born in Surrey 1946,
lives and works in London
Domestic Piece One 1980
Wood, canvas and acrylic
172 x 20 x 22 cm
Bought 1981
(Text p.36 Illus. p.21)

Leonard McComb
Born in Glasgow 1930,
lives and works in London
Peaches in a Glass Stand 1982
Pencil and biro on paper on cotton
136.5 x 113 cm
Bought 1982
(Text p.37 Illus. p.41)

Alastair MacLennan
Born in Blair Atholl, Perthshire
1943, living in Northern Ireland
since 1975
Drawing from 'The On' series 1988
Charcoal on paper
152.5 x 122 cm
Bought 1988
(Text p.37 Illus. p.59)

Andrew Mansfield
Born in Leicester 1953,
lives and works in London
Nature Morte 1985
Oil on canvas
195.7 x 167.6 cm
Bought 1985
(Text p.43 Illus. p.42)

Ben Nicholson
Born in Denham, Buckinghamshire
1894, died 1982
Bocque 1932
Oil on board
48 x 78.5 cm
Bought 1950
(Text p.44 Illus. p.49)

Ron O'Donnell
Born in Stirling 1952,
lives and works in Edinburgh
*The Antechamber of Rameses IV in
the Valley of the Kings* 1985
Colour photographic print
82 x 101.5 cm
Bought 1988
(Text p.46 Illus. p.56)

Carl Plackman
Born in Huddersfield 1943,
lives and works in London
Wardrobe 1980
Wood, metal, latex, string, clay,
cord, cardboard and paint
188 x 281.6 x 10.2 cm
Bought 1980
(Text p.47 Illus. p.58)

William Scott
Born in Greenock, Scotland 1913,
lives and works in London
The Frying Pan 1946
Oil on Canvas
54.5 x 65.5 cm
Bought 1948
(Text p.47 Illus. p.53)

Geoffrey Smedley
Born in London 1927,
lives and works in Canada
Bicameral Solids 1979-80
Fir and gesso with white shellac
180 x 46 x 30.5 cm
Bought 1979
(Text p.61 Illus. p.15)

Jack Smith
Born in Sheffield 1928,
lives and works in Hove, Sussex
After the Meal 1952
Oil on canvas
112 x 121 cm
Bought 1953
(Text p.61 Illus. p.55)

Margaret Thomas
Born 1916
The Chintz Tablecloth 1948
Oil on canvas
61.3 x 51.1 cm
Bought 1949
(Text p.62 Illus. p.32)

Suzanne Treister
Born 1958,
lives and works in London
The Black Hole 1987
Oil on canvas
213 x 153 cm
Bought 1988
(Text p.62 Illus. p.16)

Euan Uglow
Born 1932 in London
where he still lives and works
Still Life with Delft Jar 1958
Oil on canvas
61 x 51 cm
Bought 1961
(Text p.63 Illus. p.50)

Dame Ethel Walker
Born in Edinburgh 1861,
died London 1951
Flowers and Grapes undated
Oil on canvas
61 x 50.8 cm
Bought 1942
(Text p.64 Illus. p.33)

Boyd Webb
Born in Christchurch, New Zealand
1947, lives in Brighton and works in
London
Murmansk 1981
C-type photograph on card
106.3 x 76.2 cm
Bought 1981
(Text p.64 Illus. p.60)

Richard Wentworth
Born in Swansea 1947,
lives and works in London
Toy 1983
Galvanised and tinned steel
31 x 62.5 x 41 cm
Bought 1984
(Text p.64 Illus. p.54)

Gerard Williams
Born in Manchester 1959,
lives and works in London
Console 1987/88
Wood, plaster, plasterboard,
furnishing vinyl, oil paint, found
objects
94 x 94 x 15 m
Bought 1988
(Text p.66 Ilus. p.52)

Victor Willing
Born in Alexandria, Egypt, 1928,
died London 1988
Place of Exile 1976
Charcoal and pastel on paper
31.4 x 50 cm
Bought 1978
(Text p.66 Illus. p.13)

Bill Woodrow
Born near Henley, Oxfordshire,
1948, lives and works in London
*Armchair and Paraffin Heater with
Campfire* 1981
Plastic armchair and metal paraffin
heater
Total area variable
Bought 1981
(Text p.67 Illus. p.24)

Tour

PLYMOUTH City Museum & Art Gallery	11 February - 18 March 1989
SWINDON Museum and Art Gallery	1 April - 1 May
BARNSLEY Cooper Gallery	20 May - 18 June
DURHAM DLI Arts Centre	24 June - 23 July
LEIGH Turnpike Gallery	5 August - 9 September
BRIGHTON Gardner Centre Gallery	16 September - 22 October
(to be confirmed)	28 October - 3 December
LINCOLN Usher Gallery	9 December 1989 - 21 January 1990
LONDON Royal Festival Hall	27 January - 4 March
IPSWICH Christchurch Mansion	10 March - 22 April
FOLKESTONE Metropole Art Centre	28 April - 3 June
(to be confirmed)	9 June - 15 July
NEWPORT (*Gwent*) Musem and Art Gallery	21 July - 26 August
STOCKPORT Art Gallery	1 September - 7 October
AYR Maclaurin Art Gallery	13 October - 25 November
BATH Victoria Art Gallery	24 November 1990 - 6 January 1991

THE SOUTH BANK CENTRE